DRAWING
People

DRAWING People

Learn How to Draw Realistic Figures, Expressive Poses, and Lifelike Portraits

Lise Herzog

First published in 2019 as *Personnages: 50 modèles pour débuter* in Paris, France, by Editions Mango.

Published in the US by:
ULYSSES PRESS
PO Box 3440
Berkeley, CA 94703
www.ulyssespress.com

ISBN: 978-1-64604-245-6

Printed in the United States by Kingery Printing Company
10 9 8 7 6 5 4 3 2 1

Acquisitions editor: Keith Riegert
Managing editor: Claire Chun
Project manager: Kierra Sondereker
Editor: Kate St.Clair
Proofreader: Joyce Wu
Front cover design: Flor Figueroa
Interior design and layout: what!design @ whatweb.com
Production: Yesenia Garcia-Lopez

CONTENTS

GETTING STARTED

One of the first things children try to draw is often a person. So, why does it seem so difficult to do as an adult? What are your goals in drawing people?

When you first begin drawing, it's easy to overlook details such as line thickness, volume, and flexibility. Depending on what you're drawing, these things might not even matter. But if you're drawing a human figure, without these elements, your sketch will turn out one-dimensional and stiff—resulting in a very unsatisfying drawing. Be careful not to get too caught up in all the small details, however, or you'll forget to see the whole picture.

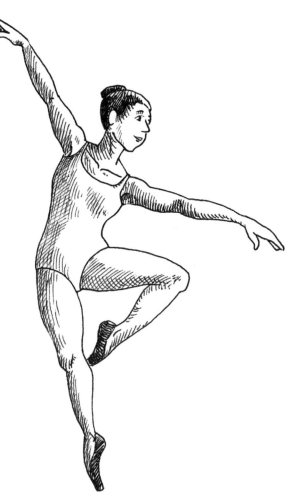

The body is made up of many eye-catching details. While some artists may tend toward a universal ideal, the only real rule for drawing a human figure is observation. Ask yourself a few questions before beginning: How big is the head in relation to the width of the shoulders? What about the length of the arms in relation to the rest of the body? During each step of your drawing, observe, question yourself, and compare one part of the body to another. Just because your characters might not have standard proportions, it doesn't mean they're not beautiful, lively, and expressive!

As complicated as the human body seems, it is actually made up of the same basic shapes that are all around us: circles, ovals, straight lines, and angles. The only variables are the number of shapes you need to assemble your character and the correct ratio between them. So before getting started, make sure to carefully observe the models. Try to envision all the different proportions coming together in order to avoid drawing, for example, legs that look like sticks. Likewise, starting your drawing with just a simple outline would risk losing the important details along the way.

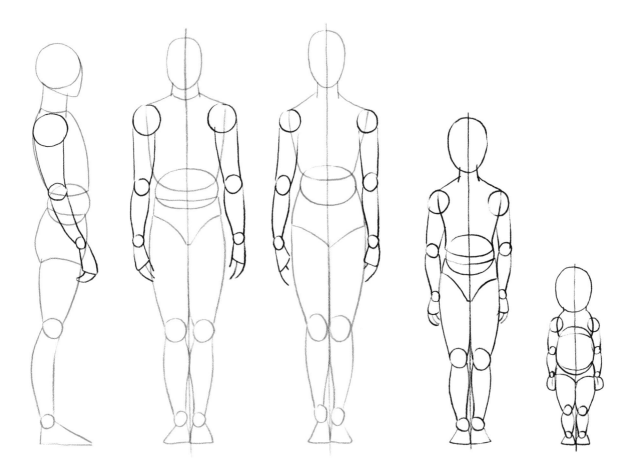

Perhaps the most difficult part of drawing a human figure is perspective. Simply put, you create perspective by making all horizontal lines run toward a certain point as they approach the horizon and all vertical lines go up or down. The body is made up of many, many straight lines. All these lines relate to each other and can converge in different directions. Thus, as soon as a character is not in a simple position—standing, facing forward, or in profile—the lines that compose them will change direction as well, in keeping with the new perspective.

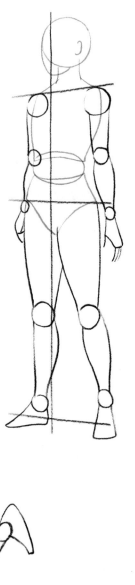
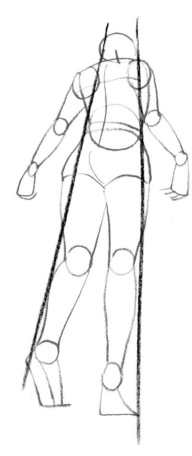
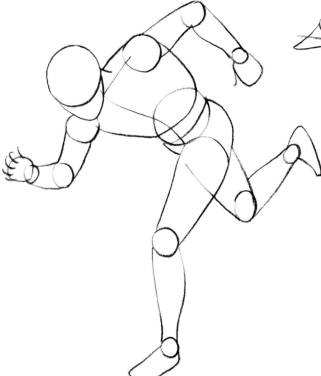

Whether you're drawing a female or male character, the basics remain the same. The main difference lies in the various sizes of certain body parts and their relation to each other. To give a character an immediately recognizable masculine or feminine identity, you have to exaggerate some of the body's proportions a little, even if it ventures toward caricature rather than reality.

Begin by drawing a framework of simple shapes that you can then "dress" by redrawing over the figure's outline. For this sketch, a graphite pencil allows for a smooth start and makes shading and erasing easy.

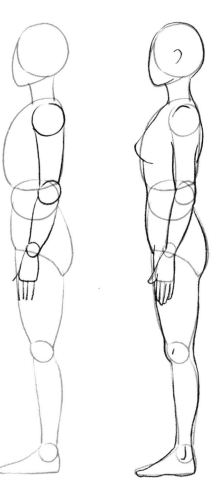

When finishing your drawing, you can add detail using any drawing tool you want. Tools like regular pencils, graphite drawing pencils, and old felt-tip markers allow you to create both light and dark lines, depending on how hard you press on the tip. Others, such as pens, markers, and India ink, will always produce the same intense black lines. However, these tools also make it easier to erase your original construction lines later on. Finally, the versatile ballpoint pen can create either very soft, light lines or very dark lines. And these lines are lasting; so if you want to rework the drawing, you'll have to use a wet technique, such as watercolor or other painting techniques.

As you observe and draw, your eye for detail will grow. One day, your character may seem perfectly balanced and alive, but the next day you feel like it's the complete opposite. Don't be discouraged. Take some time to think about your drawing and make a new one. Each drawing is an essential step on the road to progress. Whatever technique you use, take the time to try, observe, and reflect. Accept being imperfect. Each error sharpens your gaze, and each test strengthens your ability.

FEMALE BODY BASICS

A female body generally has wide hips and narrow, slightly drooping shoulders. The joints are also thinner and the curves softer.

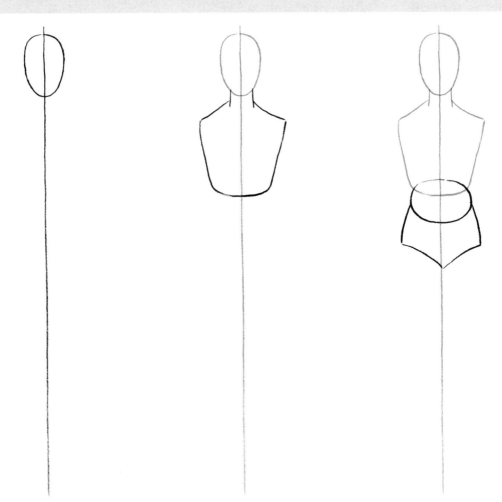

Facing forward, start with an oval for the head. Draw a long vertical line through the head as a guideline to keep your character upright as you are drawing.

Under the chin, add the neck and chest. The chest should flare out with the slope of the shoulders, getting narrower toward the waist.

The stomach is also made with an oval, indicating where the body will be able to bend at the waist. Draw the pelvis directly below in a shape similar to shorts or briefs.

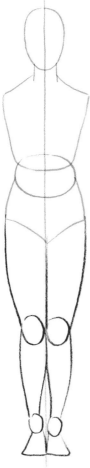
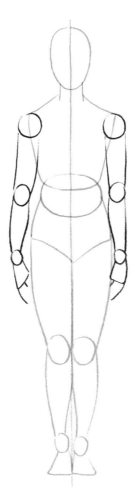
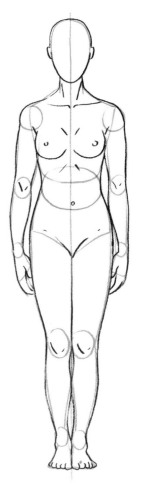

Position the legs on either side of the vertical line, making them thinner toward the feet. Draw small circles to indicate the knees and ankles, which are points of mobility. These circles also act as a reminder to draw small bumps for kneecaps at the end of the drawing.

Attach the arms to the shoulders with more circles. Do the same for the elbow and wrist joints above the hands. With the arms dangling, the hands should reach to about the middle of the thighs.

When finalizing the drawing, add small lines and curves to create the natural folds and bumps that make up different parts of the body.

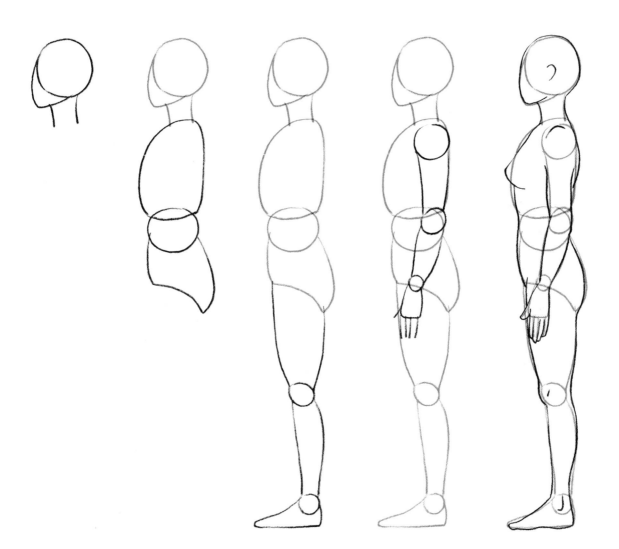

In profile, a human figure is made up of a sinuous curve from top to bottom. It starts out as a lump at the back of the head, inflates the front of the chest while keeping the back somewhat flat, bumps out at the buttocks, curves around the thigh and calf, and ends with the flat foot. The shoulders are also pushed back toward the head.

FINISH YOUR DRAWING WITH A PENCIL

Graphite pencils are great for adding shadows, which give your drawing both depth and texture. You can also easily layer lines, like the ones used for shading, to make them darker.

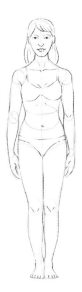

Graphite pencils come in varying intensities, but you can also add intensity to any pencil by pressing down on the tip more and by tightening or superimposing lines.

To finish this drawing, give the character an expressive face and expression and add details such as hair and clothes.

When creating volume and depth in your drawing, it's necessary to pinpoint which direction the light is coming from and, therefore, which part of the body will be illuminated. The shadows should be on the opposite side of the lit area. Start with light hatching to adjust the shadow as you go.

As you add new shadows, go over the first layer of hatchings to further darken those shadows.

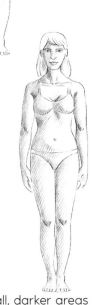

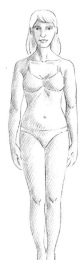

Finish by touching up a few small, darker areas to highlight the overall detail.

PRACTICE PAGES

Try your hand at finishing the original sketch.

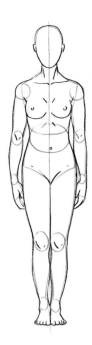

Draw your own female characters in the space below.

MALE BODY BASICS

A male body generally has bigger proportions than a female body. The shoulders are broad and square, and the hips are narrow. The joints are thicker, and muscles can be more developed.

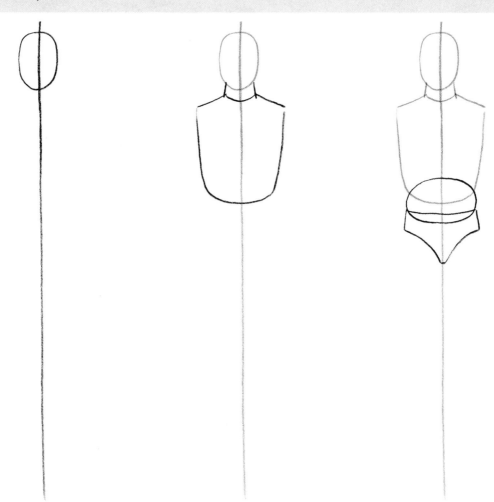

Draw a long vertical line with an oval for the head at the top.

You can draw the neck wide, with the top of the torso being quite square.

The hips are not very wide, and the torso is mostly straight, so the waist is less pronounced.

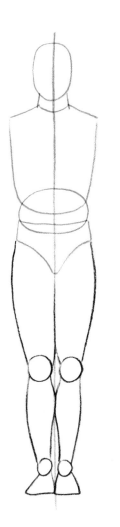

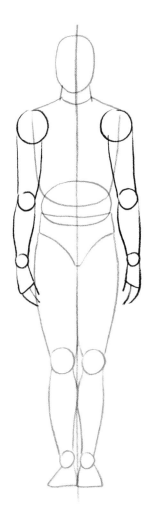

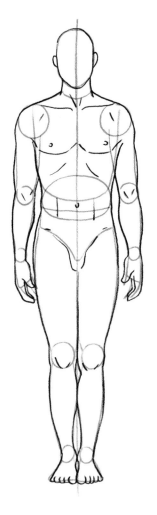

Add the arms and legs by sketching small circles at the joints. These joints can be slightly bigger than those on the female body.

Go back over your character, drawing various lines that emphasize the muscles and folds of the body.

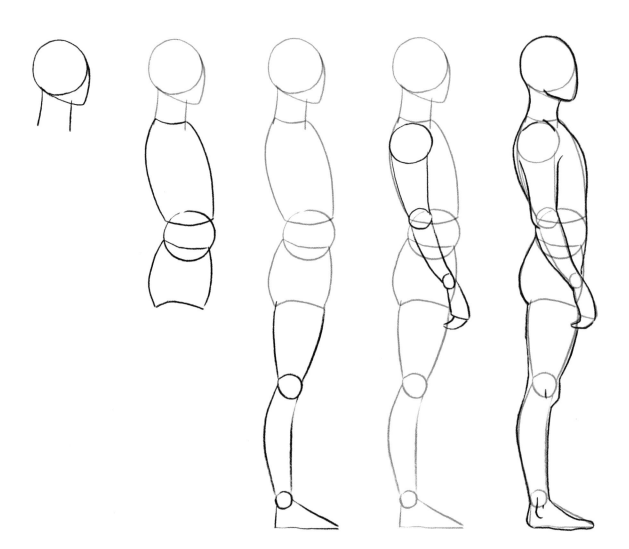

In profile, you can once again see the sinuous curve of the body, with the shoulders pushed back toward the head.

FINISH YOUR DRAWING WITH A THIN FELT-TIP PEN

A thin felt-tip pen isn't the best tool for creating different line thicknesses, but its stiffness works well for creating a fairly straight line.

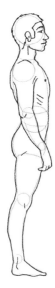

Begin by tracing over your drawing, adding a few small details here and there to give your figure some character. Then erase the original pencil lines.

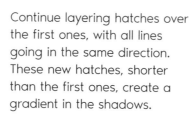

Add elements of light by placing a series of spaced hatches on one side of the body. It will appear as if the light is shining on the opposite side of the body.

Add more small hatches to emphasize some of the smaller body details.

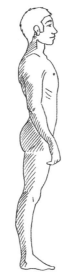

Continue layering hatches over the first ones, with all lines going in the same direction. These new hatches, shorter than the first ones, create a gradient in the shadows.

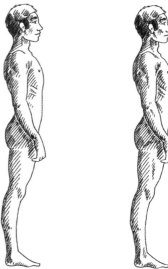

Finally, add a few finishing touches with the felt-tip pen.

PRACTICE PAGES

Try your hand at finishing the original sketch.

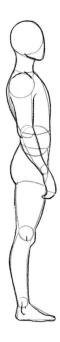

Draw your own male characters in the space below.

CHILDREN

Because children are still developing, their bodies are not as well-proportioned as adults. The hips are thin, and the muscles don't stand out as much.

When drawing children, it's best not to add too many lines that emphasize the proportions. You risk aging them more than you may want.

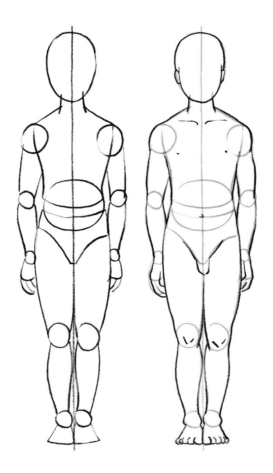

The younger the child, the larger the head should be in relation to the rest of the body.

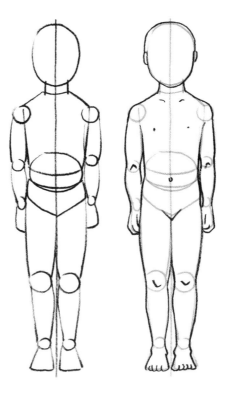

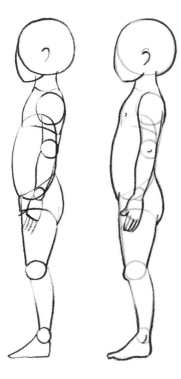

The head also stands out when in profile, while the rest of the body appears rather thin.

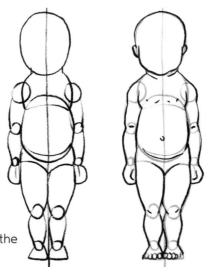

With babies, the body has more curves, and the various body parts are rounder.

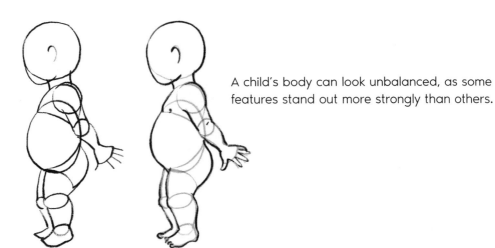

A child's body can look unbalanced, as some features stand out more strongly than others.

FINISH YOUR DRAWING
WITH A BALLPOINT PEN

The ballpoint pen, like the pencil, allows you to create lines of different intensities, from a light gray to a thick black. Just apply more or less pressure to the tip and layer the lines.

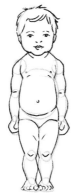 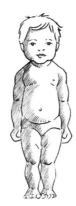 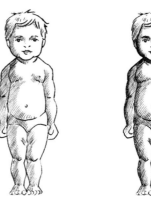

Start by drawing over your drawing with the ballpoint pen. Once the ink is dry, erase your original construction lines.

Then darken the areas you want to shade with hatching.

Add new hatching to gradually increase the intensity of the shadows.

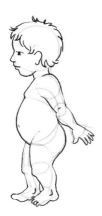 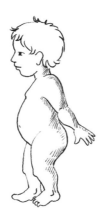 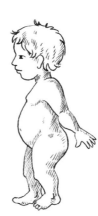 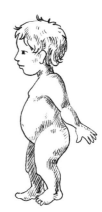

Make parts of the body stand out more by having most of the body face the light rather than the shade. Crosshatching those shaded areas will also bring a dynamic element to the drawing.

PRACTICE PAGES

Try your hand at finishing the original sketch.

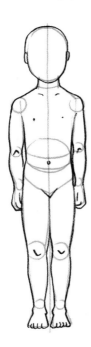

Draw your own child-like characters in the space below.

THE BODY FROM DIFFERENT VIEWING ANGLES

Regardless of the viewing angle, the lengths of the body parts remain the same. What can change, however, are the widths, angles, and silhouettes.

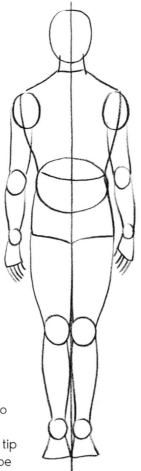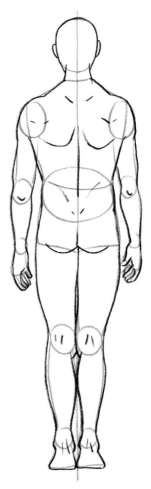

The outline does not change whether the body is facing forward or backward. What do change are the details, like the back of the head, the volume of the shoulder blades, the tip of the elbows, the small of the back, the shape of the buttocks, the small of the knees, and the hands and feet.

In this three-quarters perspective, the vertical line in the center of the body shifts to one side. This transforms the width and trajectory of several body parts. The body pivots on itself. The horizontal lines of the shoulders, pelvis, and feet drift to one side, tilting slightly to meet on the horizon.

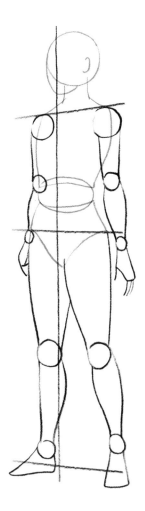

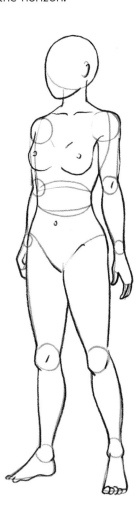

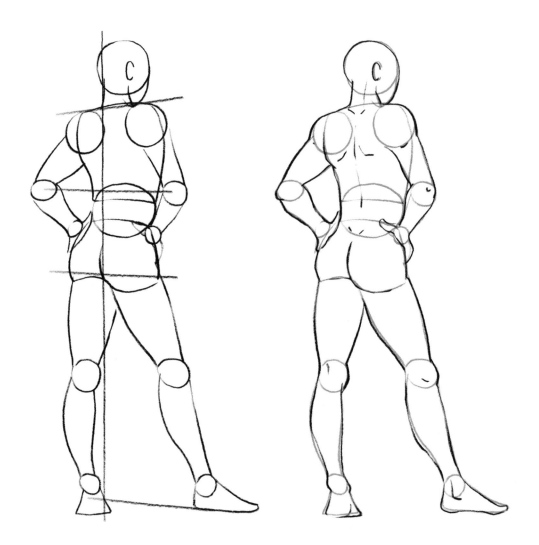

If the arms or legs move away from the body, they don't necessarily have to be on the same axis. Here, the arms remain symmetrical—the point of each elbow is on the same horizontal line. The feet are no longer parallel, with one moving to the back and the other swinging out.

FINISH YOUR DRAWING
WITH INK AND A FEATHER PEN

A feather pen is an edgy tool that can scratch the paper, so be careful. It allows for relatively fine lines and is a good tool for creating both solid lines and hairlines.

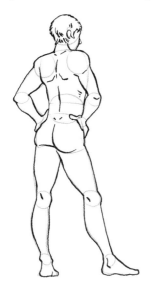

Start by tracing over the character's outline. Depending on your character's demeanor, you can press lightly or with more pressure to change the outline's intensity. Then erase the original pencil lines.

Add long hatches for shadows to give the body some depth. Sketch them going in different directions.

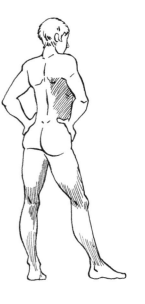

The hatching can be shorter, depending on which part of the body the shading goes on.

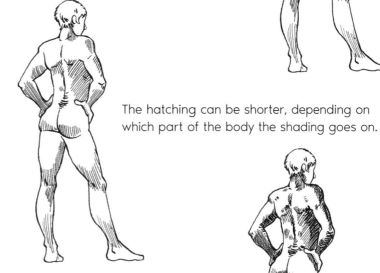

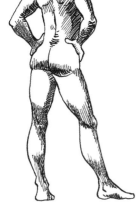

Add more hatching to gradually darken the shaded areas and to emphasize details.

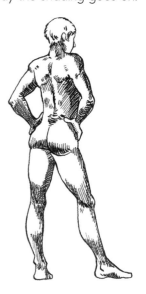

PRACTICE PAGES

Try your hand at finishing the original sketch.

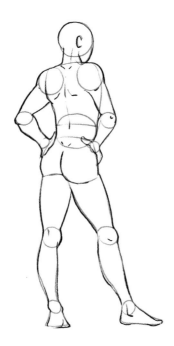

Draw your own characters from different viewing angles in the space below.

A WALKING FIGURE

To set a character in motion, use the joint areas to bend different parts of the body. The human body always coordinates its movements to maintain balance, even when it no longer has both feet firmly on the ground.

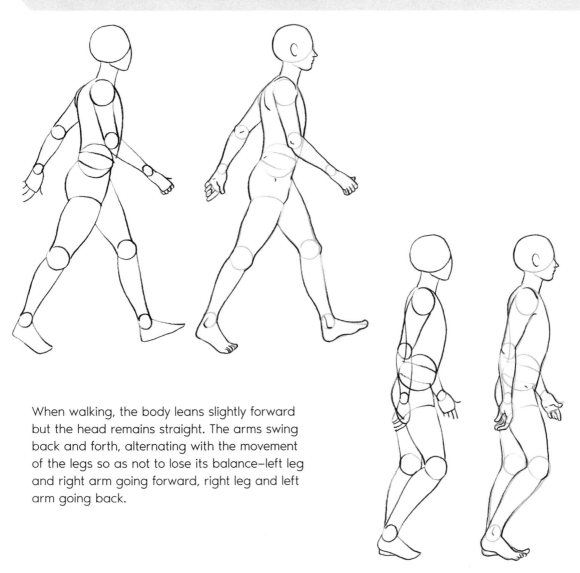

When walking, the body leans slightly forward but the head remains straight. The arms swing back and forth, alternating with the movement of the legs so as not to lose its balance—left leg and right arm going forward, right leg and left arm going back.

To move the limbs from in front of the body to behind, bring the arms and legs together at the sides and bend them slightly.

Then the arms and legs switch places.

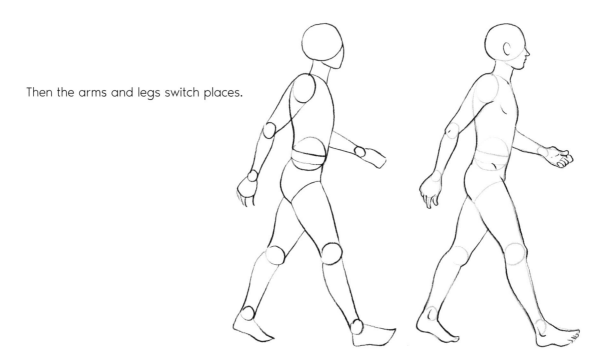

A walking body gently sways back and forth, in time to the rhythm of the steps. The hip tilts down in the direction of the leg that is moving back, which pushes the opposite leg forward. The shoulders then lean slightly toward the rising hip.

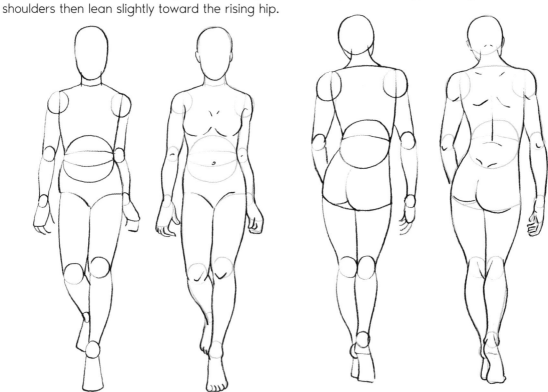

Tilt the body for a three-quarters perspective.

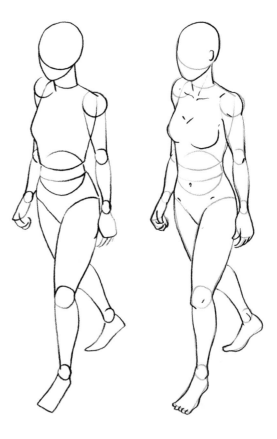

FINISH YOUR DRAWING WITH AN OLD FELT-TIP BRUSH PEN

An old felt-tip brush pen creates a line that's not completely black and has a shaky quality to it.

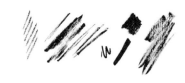

Start by redrawing your character and adding some detail. Then erase the pencil lines.

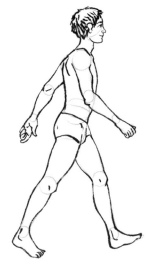

Use hatching to create a few shadows to add depth.

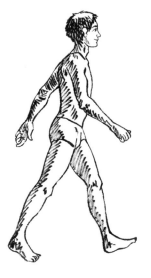

Gradually layer on new hatching, changing the direction of the line to create a sense of weight and energy.

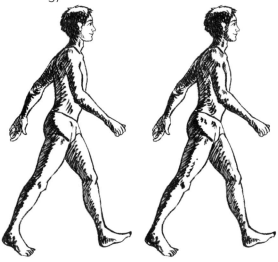

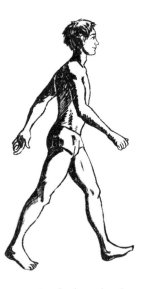

You can also create darker shadows by tightening the hatching or by pressing down on the brush tip of the pen.

PRACTICE PAGES

Try your hand at finishing the original sketch.

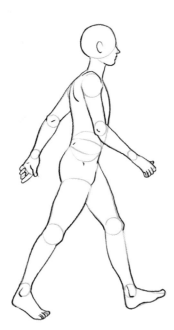

Draw your own walking characters in the space below.

A RUNNING FIGURE

The faster a character runs, the more the body bends forward, looking as if it's about to fall over.

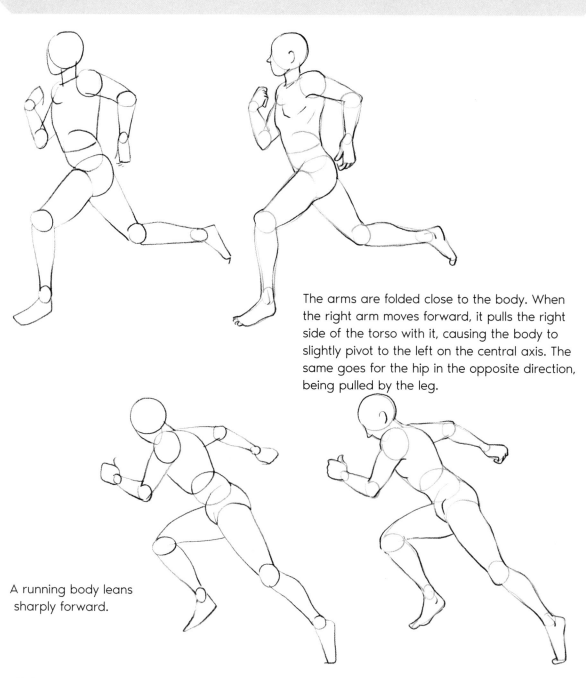

The arms are folded close to the body. When the right arm moves forward, it pulls the right side of the torso with it, causing the body to slightly pivot to the left on the central axis. The same goes for the hip in the opposite direction, being pulled by the leg.

A running body leans sharply forward.

From the front, the bent leg is put into perspective and the arms bend slightly toward the center of the body.

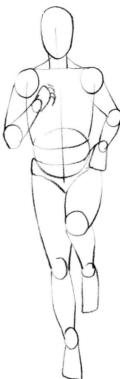
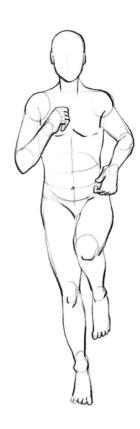

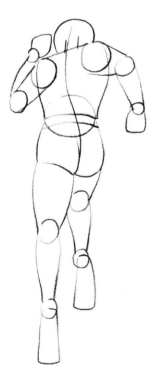
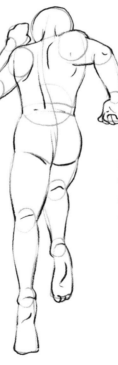

From the back, the running body has a visible twist in the spine, which comes from the shoulders and the pelvis moving in opposite directions.

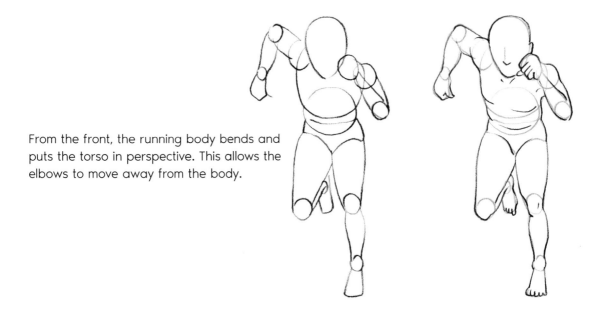

From the front, the running body bends and puts the torso in perspective. This allows the elbows to move away from the body.

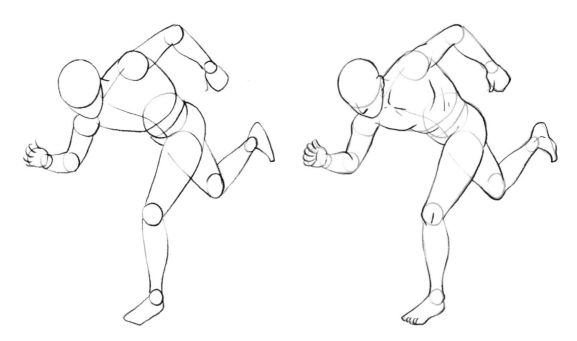

From a three-quarters angle, the arms pull the torso so that it is almost fully facing forward.

FINISH YOUR DRAWING WITH BLACK PENCIL

Black pencil makes it possible to draw rich, black colors, but also soft, powdery lines—if you don't press too hard. Be careful because it is difficult to erase!

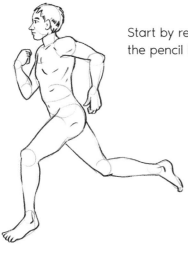

Start by redrawing the character, then erase the pencil lines of the original sketch.

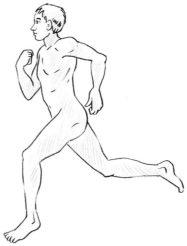

Lightly draw the first set of hatches spaced apart to add some volume.

Continue the hatching with darker lines going in different directions, but without completely covering the first layer.

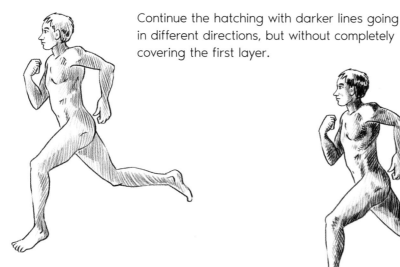

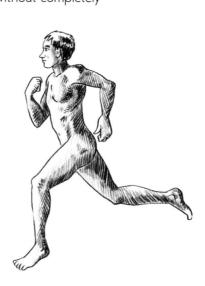

Finish the drawing by adding more depth with darker shadows and emphasizing the details.

PRACTICE PAGES

Try your hand at finishing the original sketch.

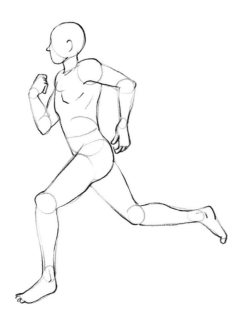

Draw your own running characters in the space below.

BODY TWISTS

As a figure leans, pivots, turns, and dances, the various body parts move at their joints, and the horizontal lines of the shoulders and hips tilt or turn on the central axis. Pay attention: everything is often in perspective!

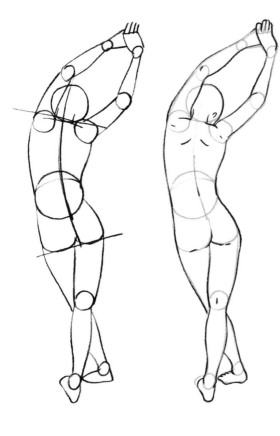

The horizontal lines of the shoulders and hips cannot bend. They can only partially pivot on the central axis or tilt. The spine, however, can bend and twist, mainly forward, a little to the sides, and very slightly to the rear.

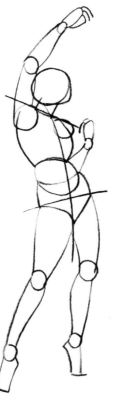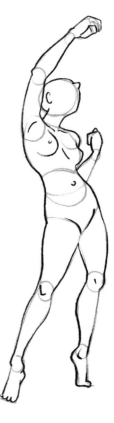

The body can lean back a bit, the twist mainly happening at the waist. If one arm is raised, the horizontal line of the shoulders is also pulled up on that side.

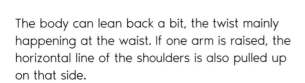

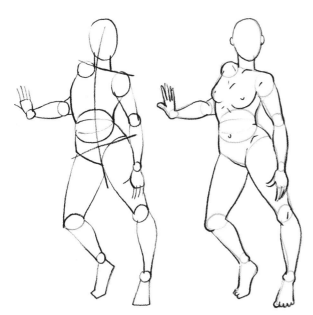

The more the figure is swaying, the more the shoulders and hips tilt toward each other on one side.

The upper body can rotate in one direction while the lower rotates in another. The torso then twists, with the horizontal lines going in different directions.

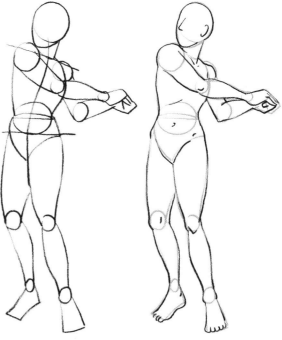

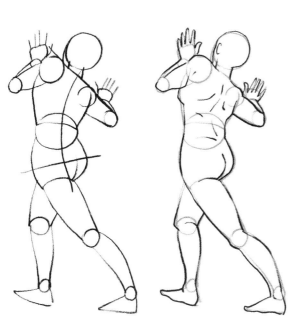

If the body is twisted a lot at a three-quarters viewing angle, the horizontal lines become even more tilted.

47

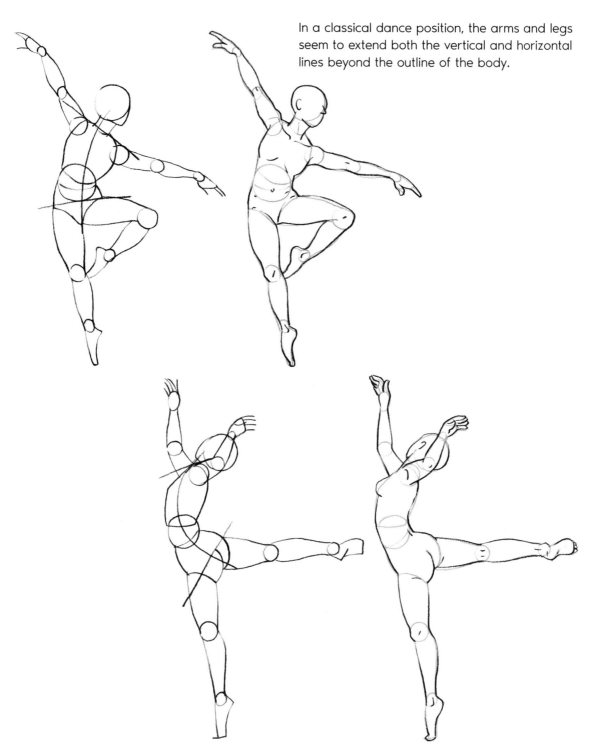

In a classical dance position, the arms and legs seem to extend both the vertical and horizontal lines beyond the outline of the body.

Every part of the body can go in a different direction.

FINISH YOUR DRAWING WITH A THIN FELT-TIP PEN

Thin felt-tip markers create very uniform lines. The tip is tubular, so make sure to hold the marker vertically to get a straight line.

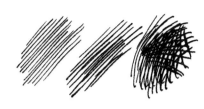

Start by redrawing the character and erasing the original pencil lines.

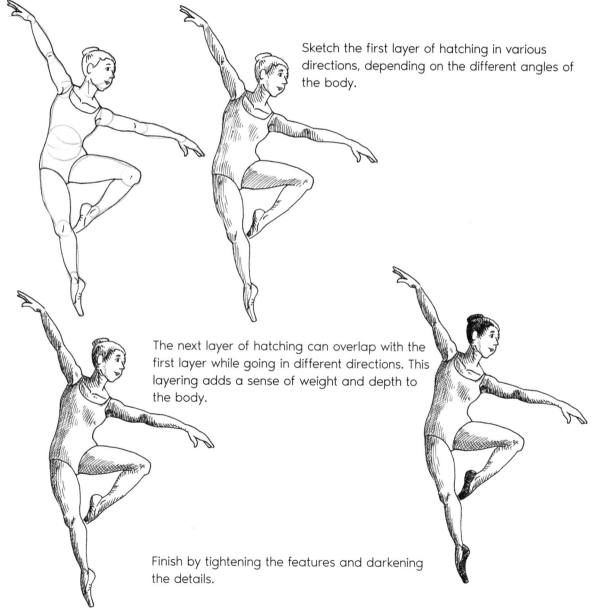

Sketch the first layer of hatching in various directions, depending on the different angles of the body.

The next layer of hatching can overlap with the first layer while going in different directions. This layering adds a sense of weight and depth to the body.

Finish by tightening the features and darkening the details.

PRACTICE PAGES

Try your hand at finishing the original sketch.

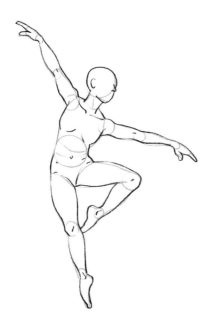

Draw your own leaning, pivoting, twisting, or dancing characters in the space below.

A SITTING FIGURE

A seated character is mainly bent at the pelvis. This position places the thighs on a horizontal line and possibly in perspective, depending on the viewing angle.

In profile, the body is all right angles, like a folded accordion. The legs are folded close to the torso.

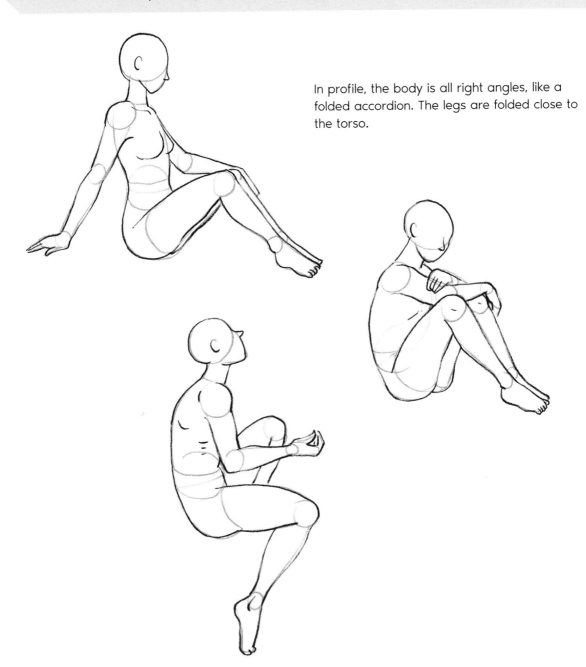

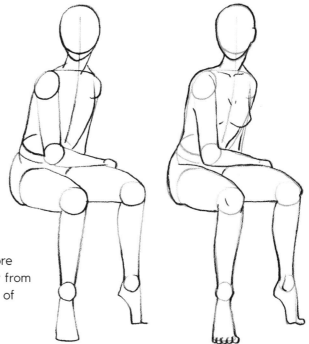

The more the figure faces forward, the more the thighs on the horizontal line disappear from view. They end up hidden by the thickness of the knees.

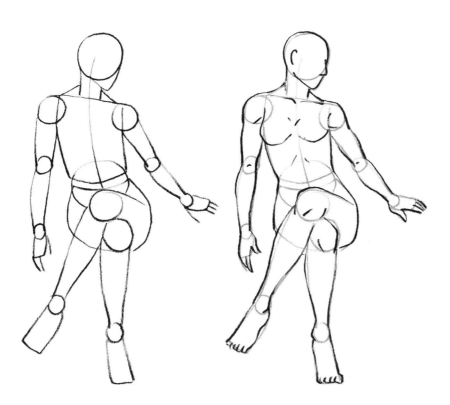

At a three-quarters angle, parts of both the front and side profiles are visible.

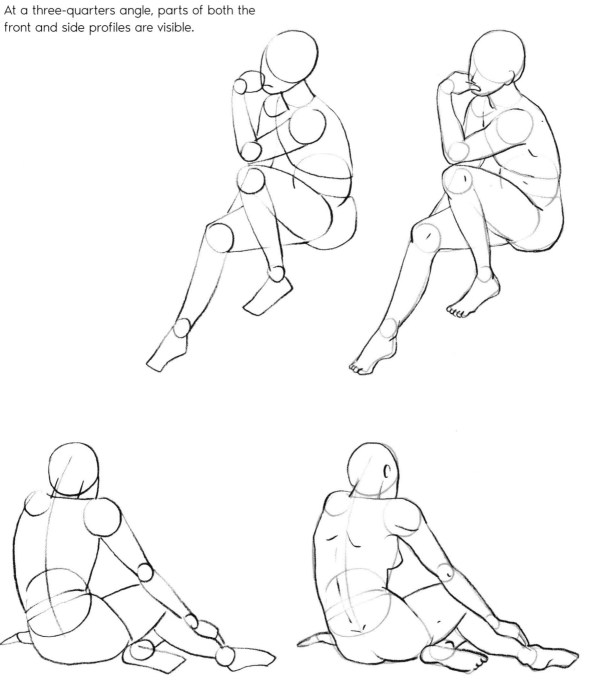

Facing the back, the thighs become hidden by the hips.

FINISH YOUR DRAWING WITH GRAPHITE AND THICK PENCILS

Graphite brings a softness to the drawing, especially when rubbed with a soft eraser, finger, or cardboard tool. By contrast, a thick pencil creates very dark lines.

Use the thick pencil to redraw the outline and details of the figure. Then erase the original sketch lines.

To add shading, create small, tight lines with a graphite pencil. Make sure not to press down too hard.

Then gently rub these lines to blur them.

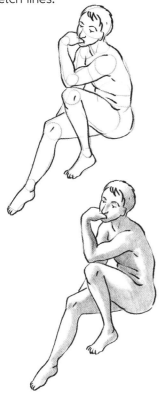

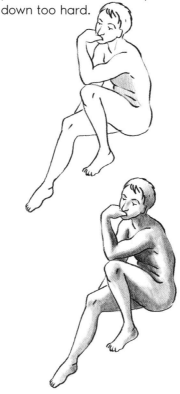

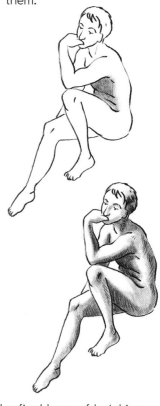

Create all of the shadows this way.

A second pass with graphite intensifies the shadows and, therefore, the light.

Add a final layer of hatching to the graphite shadows to give your character a sense of weight and energy.

PRACTICE PAGES

Try your hand at finishing the original sketch.

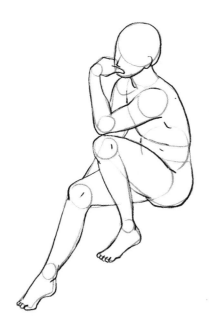

Draw your own seated characters in the space below.

A RECLINING FIGURE

When lying down, the body is placed entirely on the horizontal axis. Therefore, the proportions might look slightly different in this perspective.

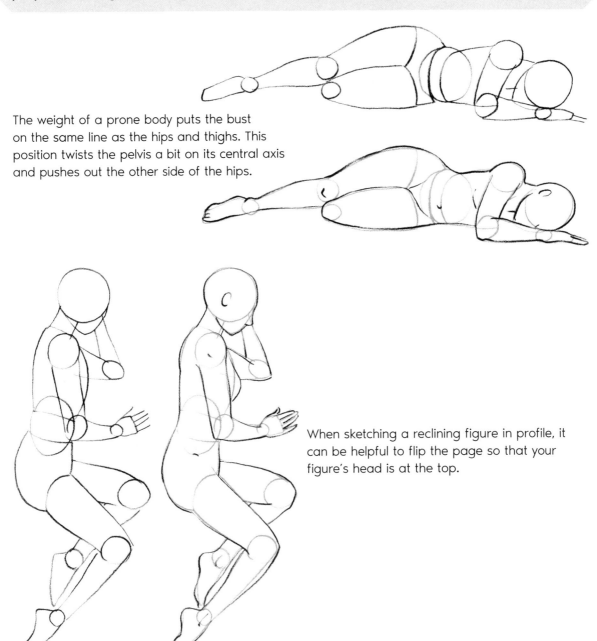

The weight of a prone body puts the bust on the same line as the hips and thighs. This position twists the pelvis a bit on its central axis and pushes out the other side of the hips.

When sketching a reclining figure in profile, it can be helpful to flip the page so that your figure's head is at the top.

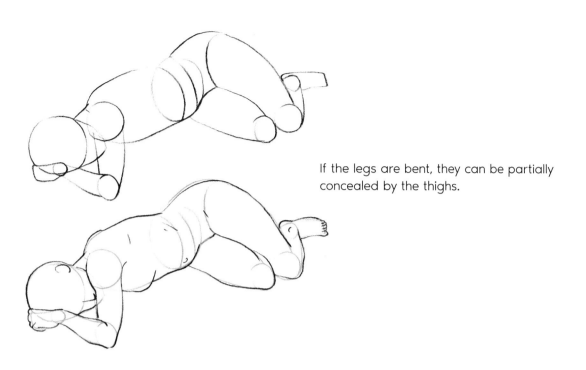

If the legs are bent, they can be partially concealed by the thighs.

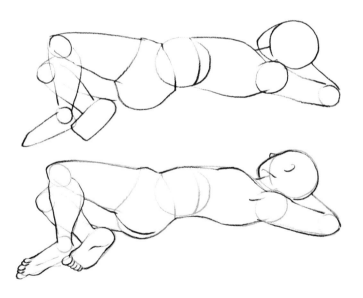

A reclining figure can twist in similar ways as when it's standing, but the horizontal lines are not the same. Instead, all parts of the body that are parallel to the ground are in perspective.

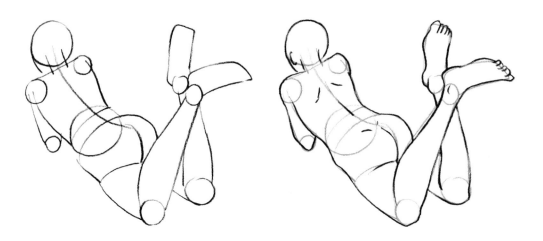

Depending on the angle, the proportions of
various body parts can change significantly.

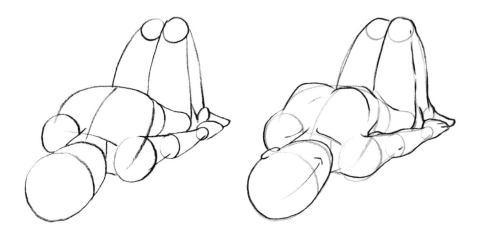

FINISH YOUR DRAWING WITH VARIOUS FELT-TIP PENS

Using different felt-tip pens lets you create lines of various thicknesses. This helps to differentiate between outlined details and shadows.

Use a thick felt-tip pen to redraw the outlines of the figure and add some details. Then erase the underlying pencil lines.

Use a thinner felt-tip pen to create shadows with hatching on one side of the body.

Because the figure is lying down, create a drop shadow underneath to prevent it from looking as if it's floating.

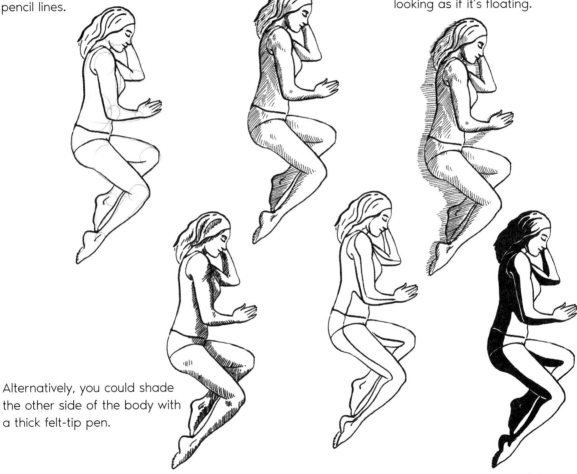

Alternatively, you could shade the other side of the body with a thick felt-tip pen.

With the marker you initially used, you can also outline the area of the body you want the light to hit, then darken the opposite side completely. Leave a thin white line along the edges of the shaded body parts so they don't lose their shape in the shading.

PRACTICE PAGES

Try your hand at finishing the original sketch.

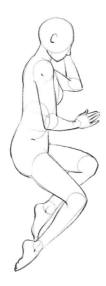

Draw your own reclining characters in the space below.

FORMS AND MUSCLES

Your initial construction sketch is often not very detailed. Its purpose is to make it easier to create an accurate proportion ratio between different body parts. From here, you can start adding curves and folds to your simple sketch, until the muscles begin to take shape.

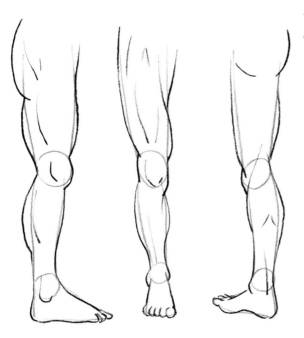

The leg mainly curves with muscle at the thigh and calf.

The arm has similar muscle proportions, but with a rounded shoulder at the top.

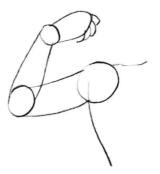 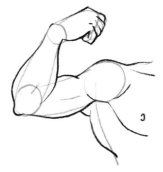

The back is made up of many muscles. Each one, as it grows, creates little folds on either side of the spine. These are the lines that indicate the size of each muscle.

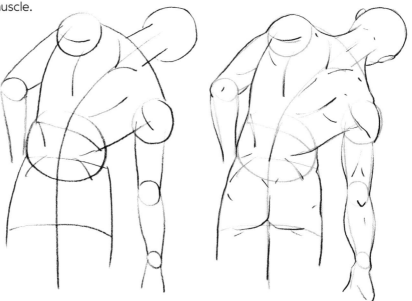

You can add volume and shape to all parts of the body using curved lines. Place them on the contours of your initial outline, on the stomach or back, and the various bends in your figure.

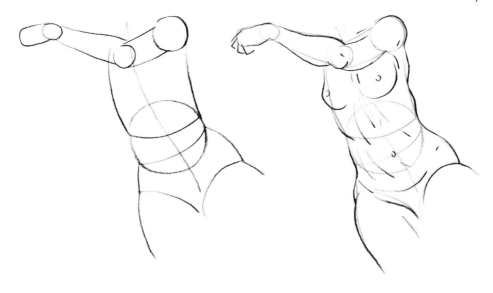

To draw an extremely muscular figure, you can draw circles and ovals on the spots where the muscles are located.

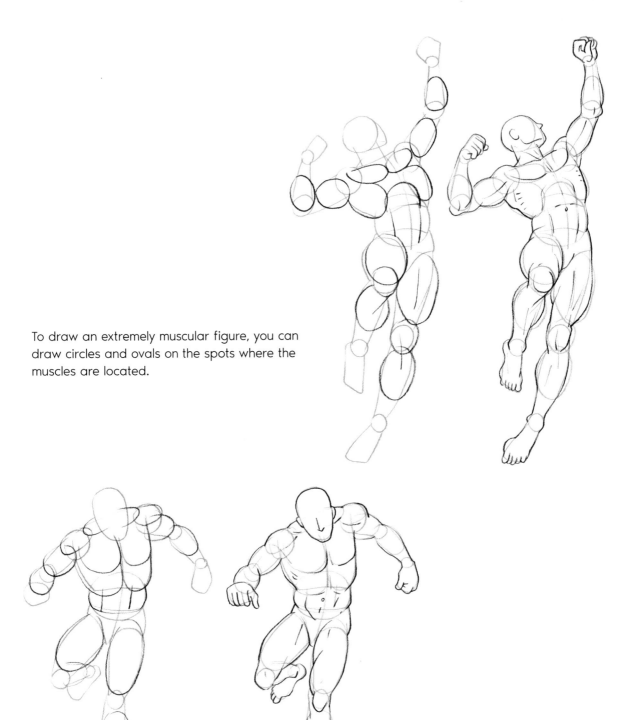

FINISH YOUR DRAWING WITH A FEATHER PEN

A feather pen creates both thick and thin shaky lines. Be careful not to apply too much pressure, as the ink can run out quickly.

Start by redrawing the outline of the figure before erasing the original pencil lines. Take this opportunity to add a few lines to suggest the volume and shape of different muscles.

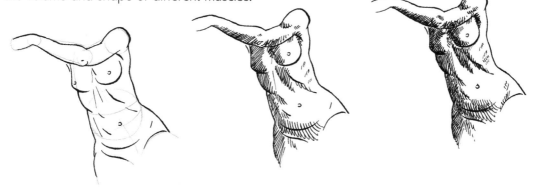

Gradually add several layers of hatching, lines going in different directions. This both accentuates the shapes of the muscles and creates a sense of light and shadows.

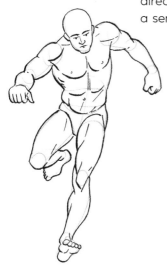
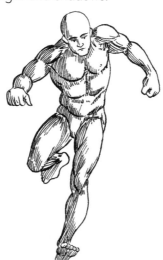
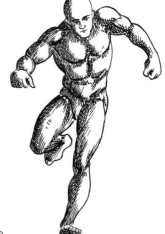

After redrawing this figure, add shadows that follow the direction of the muscles in order to exaggerate these shapes. You can stop there or add another series of hatches going in other directions to really intensify the shadows.

PRACTICE PAGES

Try your hand at finishing the original sketch.

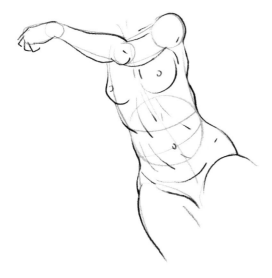

Draw your own characters with muscles, curves, and more in the space below.

POSITIONS AND POSES

A character's pose is what gives them attitude and life; it places them in a story and gives them a tangible personality.

As long as the arms and legs are primarily positioned reaching up or down, their size and proportions will change very little in any perspective, compared to the rest of the body.

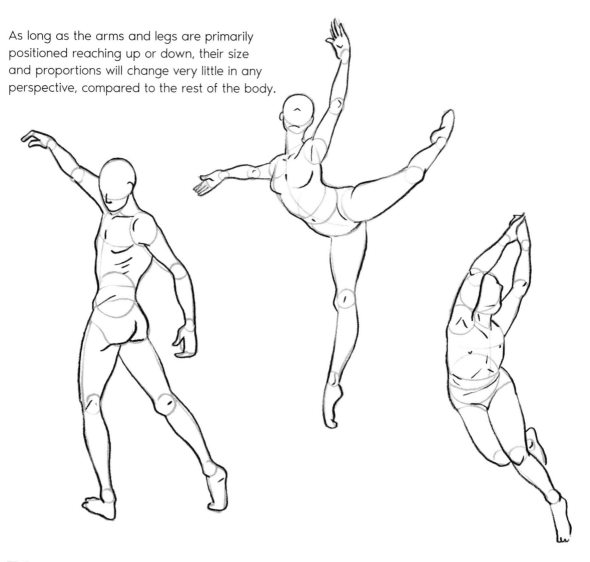

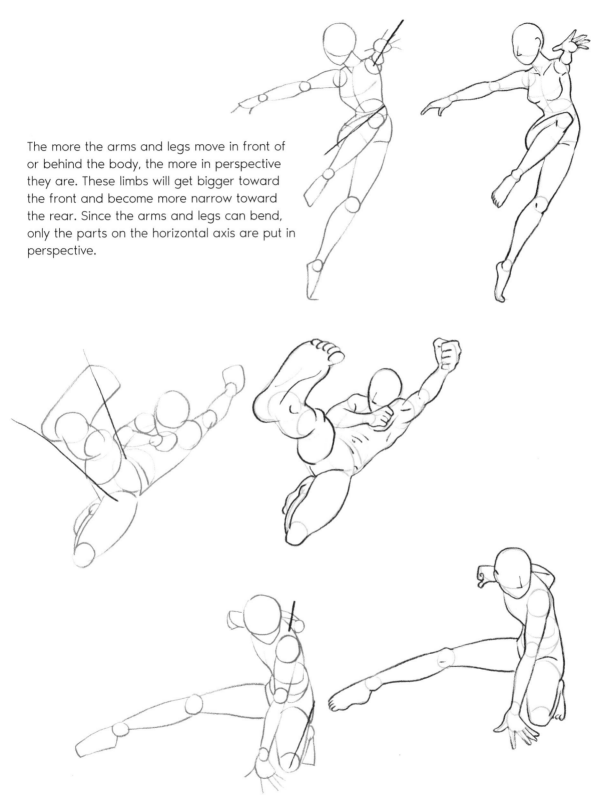

The more the arms and legs move in front of or behind the body, the more in perspective they are. These limbs will get bigger toward the front and become more narrow toward the rear. Since the arms and legs can bend, only the parts on the horizontal axis are put in perspective.

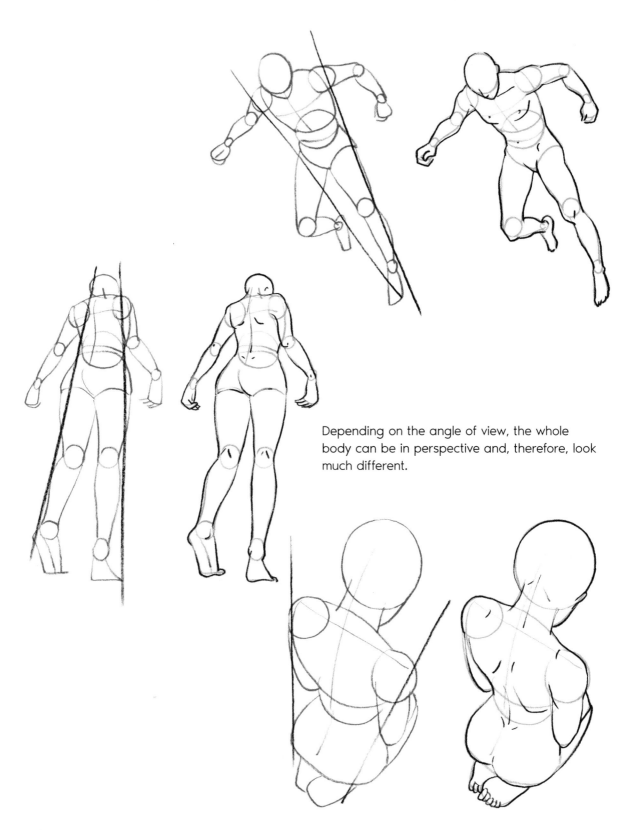

Depending on the angle of view, the whole body can be in perspective and, therefore, look much different.

FINISH YOUR DRAWING WITH DIFFERENT PENCILS

Using several styles of pencils on the same drawing allows you to differentiate between outlines and the shadows, creating a greater sense of movement and energy.

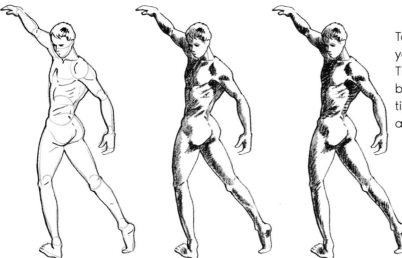

To start, trace the outline of your figure with a thick pencil. Then create various shadows by filling in some areas with tight hatching and others with a few spaced strokes.

To give the skin a velvety texture, create shadows using a softer pencil. If it seems too soft, just add a few strokes with a thicker pencil to darken some areas.

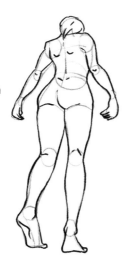

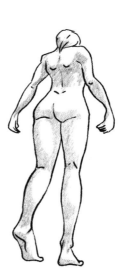

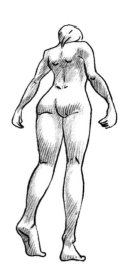

PRACTICE PAGES

Try your hand at finishing the original sketch.

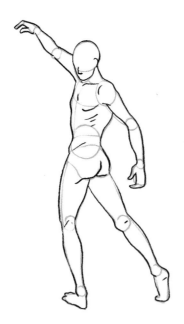

Draw your own characters in different positions and
with various postures in the space below.

DRESSING THE TORSO

Clothes adapt to the body's movements and gestures. They form folds and bumps that differ depending on the style and thickness of the fabric.

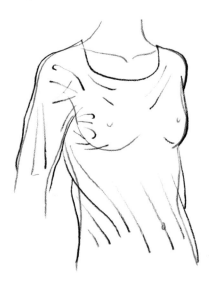

If the fabric is flexible, the folds are rounded. When various body parts stretch the fabric from underneath, there are no folds directly on top, but rather all around the sides.

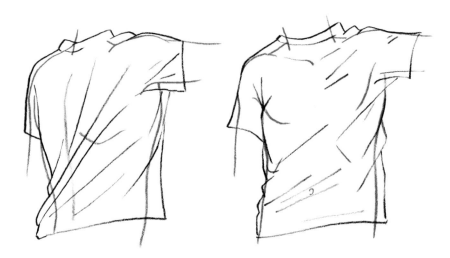

When a figure raises its arm, its shirt stretches and puckers in the same direction.

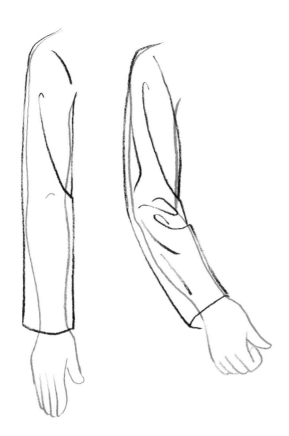

The more the arm bends upward, the more the sleeve of the shirt folds at the elbow. Long pleats gradually gather along the sleeve.

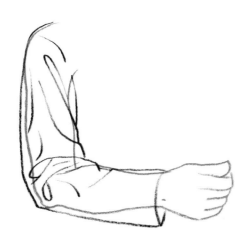

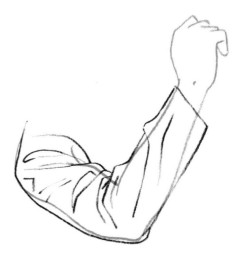

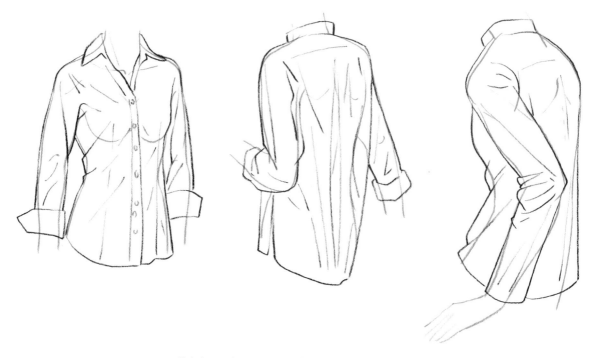

A stiff fabric shirt creates long, angular folds.

Here, the sleeve has many folds because the fabric is flexible. Because the back is flat and has greater surface area, the back of the garment falls heavy and smooth. There are pleats at the base of the hood, as the head twists the fabric when turning.

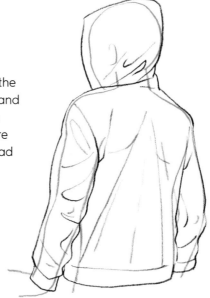

FINISH YOUR DRAWING WITH CHARCOAL PENCIL

The charcoal pencil is very dark and powdery, but if you sharpen it well, charcoal can create fine lines. You can blur and smudge charcoal by rubbing it with your finger or a cardboard tool. Be careful of the extra powder; you will have to blow on it to remove it from the drawing without smudging. You can then set your drawing with hairspray.

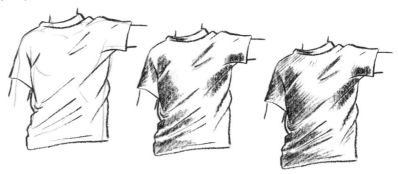

Start by tracing the outline and adding the main lines and folds of the fabric. When using charcoal, it's not easy to erase the original pencil lines of the sketch, so be very careful.

Add shadows in the areas around the folds. Adding a few thin lines of hatching on top accentuates the sense of movement.

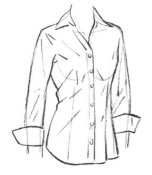

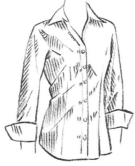

For less flexible fabric, a few spaced, small strokes are enough to show the stiffness and create some shadows between the pleats.

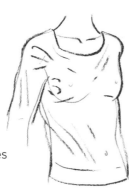

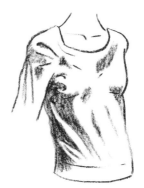

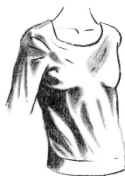

If the fabric is soft, rub the shadows to create a soft gradient that gives the clothes the appearance of satin.

PRACTICE PAGES

Try your hand at finishing the original sketch.

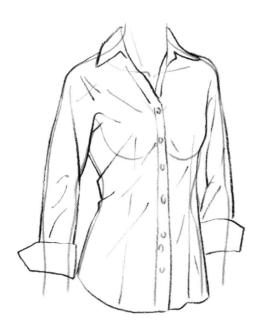

Draw your own characters wearing shirts, jackets, and more in the space below.

DRESSING THE LEGS

The legs can be separated when dressed in pants, or be together in a skirt. How the fabric folds around the body depends on either the movements of each leg or the entire lower body.

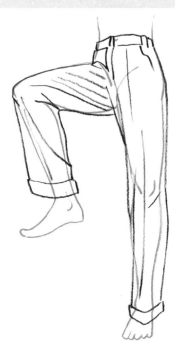

Tight, flexible pants create lots of folds at the hips, around the fly, at the knees, and at the bottom of the legs, especially if the pant legs are too long.

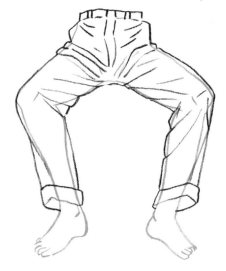

The fabric puckers up in the hollow of the knee or groin.

On a bent leg, the fabric folds back, creating a series of lines starting from wherever the body is protruding the most. On the straight left leg, the fabric falls without making any folds, except for a few natural creases in the pants.

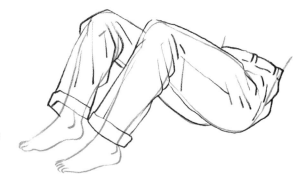

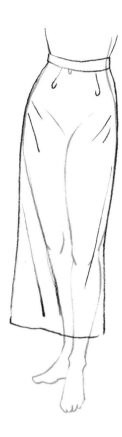

On a long, rigid skirt, the fabric makes very few folds. You only need a few lines to indicate that one leg is moving forward and pulling on the fabric.

Loose, supple fabric flares out as it falls. If held high, it creates folds that spread out as it hangs down.

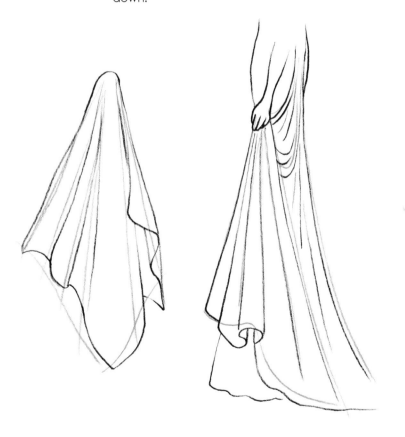

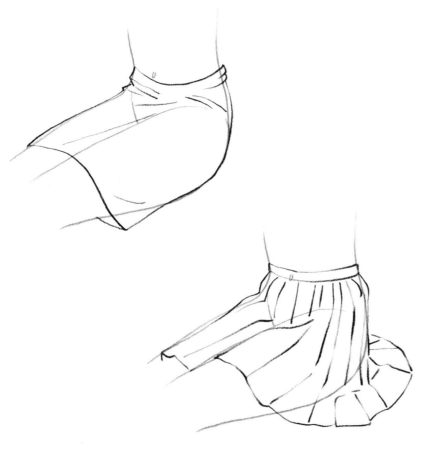

A short skirt pleats at the groin when the figure is seated. If the skirt is smooth and tight, the rest of the fabric conforms to the thigh line. If it is pleated and flared, the edge of the skirt rests on the seat, forming rounded or stiff folds, depending on the texture of the fabric.

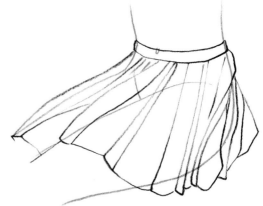

FINISH YOUR DRAWING WITH TWO FELT-TIP PENS

You can use two different sizes of felt-tip pens to create lines of varying thickness.

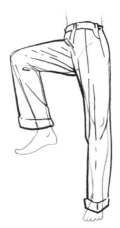 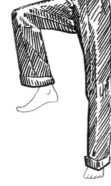 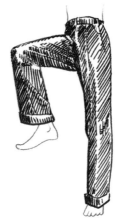 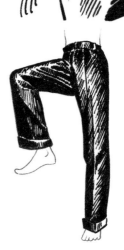

Start by tracing the outline and folds of the pants, then erase the original pencil lines.

Fill in most of the fabric with hatching, working between the outlines and the lines of the folds. The most prominent areas, like the protruding knee, remains in the light.

Continue to gradually add hatching, thus creating a "colored" fabric. You should focus not on making shadows appear, but rather on creating light.

On a pleated skirt, many details, like the areas that stick out, can be easily lost when coloring the fabric. It is therefore necessary to balance the shaded areas with some lighter sections.

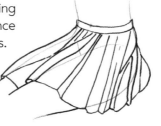 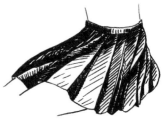

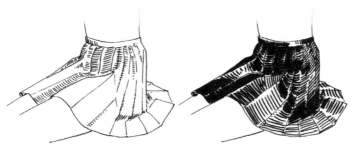

The direction of the hatching can also change the fabric's look of stiffness or flexibility.

PRACTICE PAGES

Try your hand at finishing the original sketch.

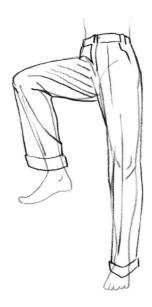

Draw your own characters wearing pants, skirts, and more in the space below.

THE FOLDS AND GATHERS OF FABRIC

In addition to following the body's movements, fabric can also fold in certain ways depending on the style and shape of the garment.

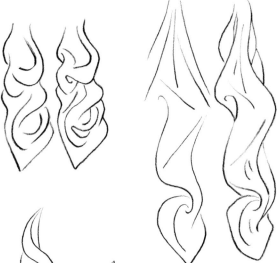

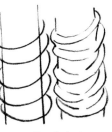

Twisting a soft fabric results in rounded folds, like waves.

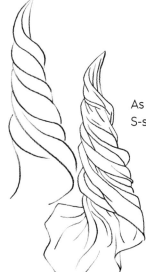

As it rolls up, fabric creates long, angled S-shape folds.

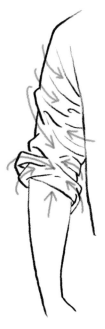

As a sleeve is rolled up the arm, the fabric gathers in several circular patterns, with small, hollow folds in between.

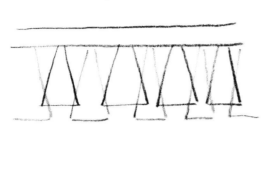

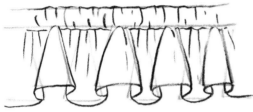

Fabric gathered on a horizontal line has a zigzag fold, with the folds alternating above and below. These folds then flare out as they hang down.

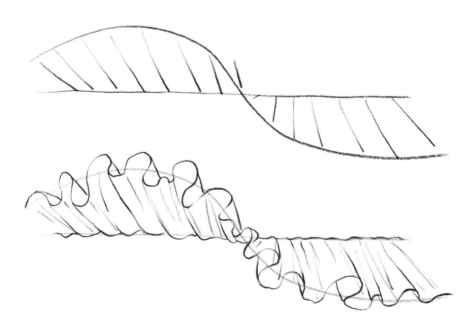

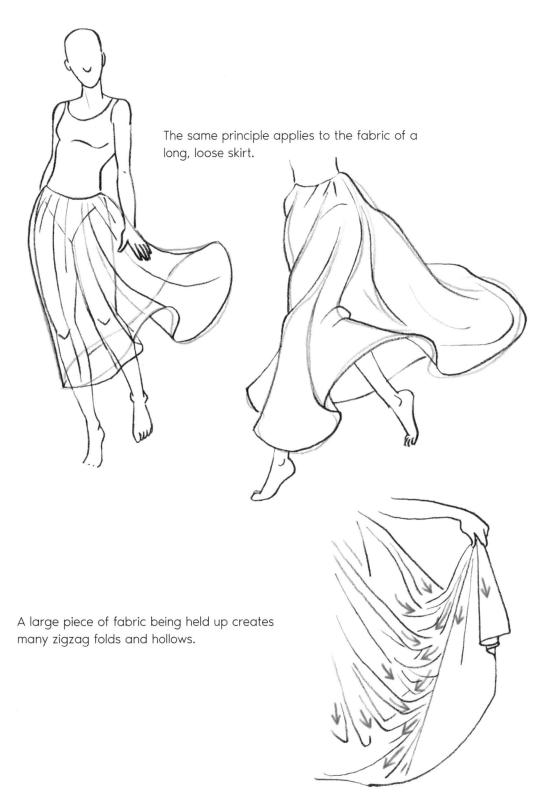

The same principle applies to the fabric of a long, loose skirt.

A large piece of fabric being held up creates many zigzag folds and hollows.

FINISH YOUR DRAWING WITH A THICK PENCIL

A thick pencil allows you to draw lines that are dark and rich, or ones that appear soft and powdery—if you don't press too hard. However, be careful, because lines made with this pencil don't erase well.

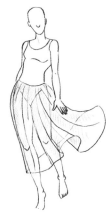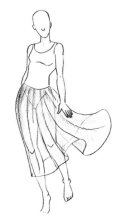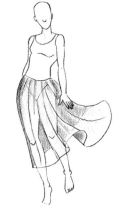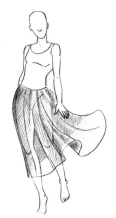

To create a look of transparency, fill the hollows between the lines of the folds with light hatching, leaving areas of white near the bottom of the skirt and the top of the pleats to give the effect of light shining through.

Enhance the transparency effect by adding more shading behind the legs, while leaving only a thin layer of hatching on the front of the skirt.

To accentuate the fabric's movement and flexibility, sketch pencil lines in the direction of the curves. Darken the shadows on one side, between folds, and on the underside of the skirt.

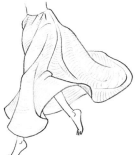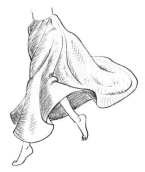

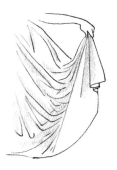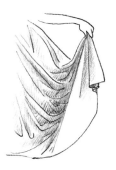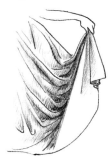

On heavily pleated fabric, concentrate most of the shading in the area with the most pleats. Keep the large sections of smooth fabric relatively clear.

PRACTICE PAGES

Try your hand at finishing the original sketch.

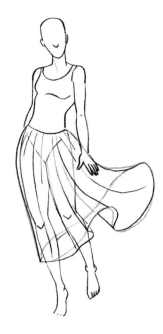

Draw your own characters wearing various types of fabric in the space below.

ABOUT THE ILLUSTRATOR

LISE HERZOG was born in 1973 in Alsace. From an early age, she used a ballpoint pen to fill drafts of A4 paper with drawings. In search of precision, she observes and redraws every day, certain she has figured out how to represent things and disappointed the next day. So she starts again. This is how, quite naturally, Herzog began pursuing her quest at the University of Plastic Arts and then at Decorative Arts in Strasbourg. In 1999, with her diploma in her pocket, she presented her sketchbooks to publishing houses—and so began her illustrative journey. The same year, she was selected to attend the Bologna Book Fair. Since then, she has illustrated many books, for young people and adults, both fiction and documentaries. Lise Herzog is also the author of several drawing books, including *Drawing Animals* (Ulysses Press, 2020); as well as *The Easy Drawing*, *The Successful Drawing*, *Easy Color*, and *Easy Perspective and Composition* from the French publishing house Editions Mango.

DISCOVER MORE DRAWING BOOKS FROM ULYSSES PRESS

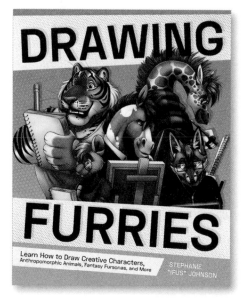

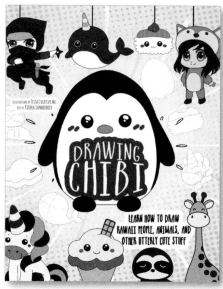

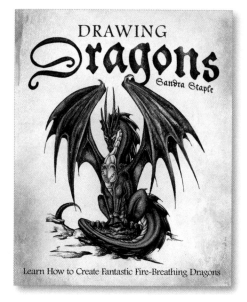

www.ulyssespress.com/drawing